Table of Contents

Part One: Introduction

 About this book………………………………………………………………..1

 Learning to draw…………………………………………………………….…..2

 Things to think about while drawing……………………………………..…..3

Part Two: Artistic Theory and Exercises

 Different types of drawing……………………………………………………..4

 The left and right side of your brain: turning on your artistic mind…....6

 The five basic skills of drawing…………………………………………..…..7

Part Three: Tutorials

 People

 Eye………………………………………………………………...12

 Face……………………………………………………………….14

 Figures…………………………………………………………….16

 Animals

 Bird………………………………………………………………...18

 Dog………………………………………………………………...20

 Bunny……………………………………………………………...22

 Objects in nature

 Rose………………………………………………………………..24

 Leaf………………………………………………………………...26

 Tree………………………………………………………………...28

Conclusion………………………………………………………………….31

Part One: Introduction

About this book

Hello, my name is Emily Dow. For my English class in eighth grade, we have been assigned a year-long project called a Passion Project. For this project, we got to choose any topic that we are passionate about to research and develop a final product. So I started to think – what am I passionate about that I could research and turn into a product that would better both myself and others?

Ever since I was little, I have always had a passion for art. Art is a great way for me to relax and express myself. However, I realize that this isn't the case for everyone – many people say that they dislike art because they think they aren't good at it. So, I thought to myself, *how can I help people build confidence in their ability, find their artistic spirit, and grow in their artistic skills?* What better way is there to do that than to create a how-to-draw-book?

I know that many people find how-to-draw books difficult to learn from and only feel more frustrated after trying to learn how to draw something new. So, I outlined a motivational and educational process of learning art, through my research, to help solve that problem. I hope that you find my book inspirational and helpful and come out a more confident artist after using it. Please enjoy my innovative drawing book!

Learning to draw

Did you know that anyone can learn to draw? All you need is paper, a drawing utensil, and a positive mindset!

Many people believe that artistic ability is a natural talent and that you are either born an artist or are not. This is not the case! The reason some people appear to be more talented at art than others is that certain people were more artistically observant at a very young age, which allowed their brain to be more open and coordinated to drawing what they observed and visualized. This enabled them to be able to easily replicate something that they want to draw, making them look more 'artistic' to others. However, anyone can open their brain to learning this talent and looking at things from an artistic perspective at any age! It may take a little bit longer, but it by no means makes you any less capable of learning art now. Just remember to be patient and practice.

This book will give some methods to use to help open your mind to thinking artistically. It also contains some step-by-step tutorials on drawing people, objects, and animals. Hopefully you have fun expanding your artistic ability with this book!

Things to think about while drawing

- Drawing takes practice!
 - This book will include some methods and exercises to help you practice certain skills to use when trying to draw a final product.

- Focus on small details to help improve your overall result.
 - If you are not satisfied with your picture, try thinking about different details within your art that you could fix. Fixing even the slightest of details can really improve your artwork. The exercises and artistic theory in this book will help you realize some areas in which you could think about things from a different angle to improve your artwork.

- Mistakes are okay and good!
 - You have probably heard that mistakes are what we learn from; this is especially true in art. When you feel that you messed up on a drawing, use it as a learning experience for what you can do to improve next time.

- Not everything you draw has to be a final product.
 - Making practice drawings will help you build confidence in your drawing ability. It will also make your final products better since you already made a rough-draft and found areas that you could improve upon.

- Drawing is about using your imagination – not just copying.
 - Your drawings aren't supposed to look identical to the drawings that are taught in this book or elsewhere. Every drawing is going to look a little different, even if two people are drawing the exact same thing. These differences are what make our artwork unique and ours.

Part Two: Artistic Theory and Exercises

The following pages will contain some exercises and methods based on artistic theory. These methods are very useful in improving your art in general. When you are trying to draw things both within this book and outside of it, remember to keep these exercises in mind, and you will see an improvement within your artwork. Remember when learning this section to have an open mind to trying new things and looking at things in different ways — it will help!

Before we begin with any real exercises, let's clear up some different kinds of drawing, and when each is most useful.

Different types of drawing

1. <u>Observation Drawing</u> is drawing an object by observing it. Other methods and exercises within this book will help your observational skills by teaching you ways to better observe relations within and object and copy them onto your paper. Observing new objects and trying to draw them will also help you find new things to observe in an object and will help expand the accuracy of your independent drawing outside of this book. Within observation drawing, there are two additional categories: gesture drawing and blind contour drawing. Using a combination of both types of observation drawing will help your artwork become both effective and expressive.
 a. <u>Gesture Drawing</u> is a rapid form of drawing where you begin in the center of the object in which you are observing and quickly fill in the object with no outline. This type of observation drawing is not as exact in terms of small details since it is very fast-paced, but it adds expressiveness to your artwork. It is good for drawing people, animals, and objects in motion to display emotion in your artwork.

b. <u>Blind Contour Drawing</u> is observing an object or shape and drawing it based on the details you see, starting at the edges of the figure. This type of drawing is very precise and deliberate. The step-by-step tutorials in this book mostly feature blind contour observation drawing because you will try to replicate, in detail, the figure in this book.

2. <u>Imagination/Invention drawing</u> is drawing an object from your imagination. This can come from memories you have had, or it can be designing something new in your mind and drawing it on paper. Imagination drawing is a great way to help your creativity and your artistic skill. When imaginatively drawing, make sure to refer back to some of the things you observed about objects through observational drawing, as this will make the object look more like it does when you envision it in your mind by improving its accuracy.

So which type of drawing is best? The answer is that a combination of every type will make the strongest positive impact on your art. Using both gesture and blind contour forms of observational drawing will improve the emotion and accuracy of your artwork, and using imagination/invention drawing will make you more creative and will allow you to draw more things independently. Also, keep in mind that different people learn best different ways: some people need to see something drawn step-by-step to replicate it accurately, others just like to observe an object and draw it for themselves, and some may draw best when they are not observing anything and it all comes from within their mind. Drawing more things will help you to learn what works most effectively on you, and it will improve your artwork.

The left and right side of your brain: turning on your artistic mind

As some of you may already know, there are two different sides of your brain, each with its own specific purpose in your thought process. The left side of the brain is the side that we do most of our every-day logic and thinking with. But when it comes to drawing, the left side of our brain can cause us to feel like what we are drawing is too difficult and we are not good enough. It can also make it harder for us to observe the relationships within an object to draw them. Next time you try to draw something, try to turn this left side off, and instead use the right side of your brain - the creative, artist side. You can do this by simply observing a figure and drawing what you see within the figure [e.g. lines, shadows, and relationships]. When doing this, try not to focus on drawing the actual object that you are trying to draw, but instead think about shapes in the object and the relationship between the parts of the object. For example, if you are trying to replicate a picture of a face, using the left side of your brain would be to name out and try to draw all of the different features. Using the right side, however, would be drawing all of the curves, lines, and shapes in the face as they appear in relation to each other. When you access the right side of your brain, you are allowing yourself to see the relationships of the shapes, angles, sizes, and curves in what you are drawing. The following theory about Betty Edwards' five basic skills of drawing in her book *Drawing on the Right Side of the Brain* will help you to be more observant of these relationships and how to put them into your picture

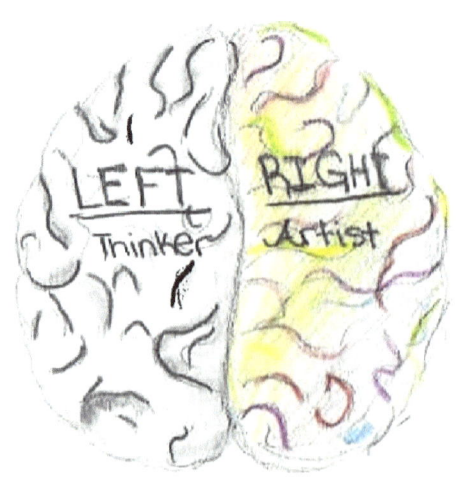

The five basic skills of drawing

The following section contains information on Betty Edwards' five basic skills of drawing in her book *Drawing on the Right Side of the Brain* and how to apply them to your art.

1. **The Perception of Edges**
 - an **edge** can be defined as a boundary separating two areas. In order to achieve a realistic drawing, we need to look for **sharp edges**, found in areas of high contrast, like intense shadows, and **soft edges**, found more in gentle curves and areas where the light and shadow within the object do not have as much contrast. In art, the perception of edges can be used to bring certain points of a drawing into focus, by drawing more sharp edges in those areas. One way to see this is in a portrait, where the focus point, the area around the eyes and nose, has hard edges with more contrast, while the area around the cheeks has a lower amount of contrast.

2. **The Perception of Spaces**
 - The **positive space** in a figure is the area that makes up a figure. The **negative space** is the area around the edges of the figure (i.e. the background). When observationally drawing, try focusing on the negative space of the figure to draw more accurately what you see. If you find drawing a certain figure to be difficult, then drawing the negative space and edges around the figure will help you because before you know it, the figure will be formed without you even consciously drawing the actual figure!

3. **The Perception of Relationships**
 - In art, everything is relative. For example, a grey shadow looks dark on a white background, but looks light in comparison to a black shadow. Another example of relativity is in edges and spaces, like comparing measurements in a portrait. One way to make sure that you have accurate relationships is by holding your pencil against a line or space of something and measuring it

mentally against the pencil. This way, you can lay the pencil against your paper that you are drawing on and make a mark to know where or how large you should draw the object to have proper relativity of what you are trying to replicate. We will get into the relationships between light and shadow in the next skill...

4. **The Perception of Light & Shadow (Shading)**
 - Again, shading is relative, so it is important to observe an object closely when drawing it to get the correct proportion between light and dark areas. If light from a source is shining on an object from the right side, then a shadow will form on the left side where the light is blocked. To show this relationship in your picture, press down on your pencil the hardest to create the darkest effect where there is the most shadow, and leave the lightest areas – the ones in direct light – white on the paper. So how can you see where the lightest and darkest areas are? To help see the values in an object or picture, you can squint at it. Squinting helps remove the other details, so that you get a better focus on the light and dark values. Here is another exercise you can do to help you with the shading skill:
 1. Place any simple three-dimensional object you can find in your home, such as a ball, under a light source, such as a desk lamp, in a dark room. Look for the lightest sections, where light reflects off the object, and the darkest sections, where there is no light, resulting in shadow. Then, try to draw the object by observing these areas. Create different shadow tones by pressing down on your pencil with different pressure amounts. You can practice creating and observing these shadow tones on a separate sheet of paper so that you become comfortable with applying them to the object. You can also purchase a paper blending stick to darken the shadows and soften them as you blend them together. If you chose to, instead of using a regular pencil, you can purchase pencils with different tones and hardnesses. This is totally optional, as using a regular pencil with different pressure amounts will still give a wide variety of tones. Here is a line showing different shades of a 2B pencil by applying different pressure amounts:

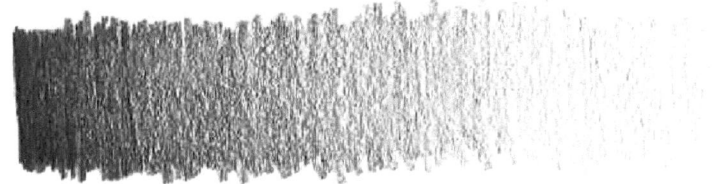

After you are done replicating this simple object, to draw and shade more complex objects that are not in front of you, refer to the relationships in your picture of this simple object to visualize where shadows and highlights would appear. Here is an example of what this simple object may look like after completing this exercise:

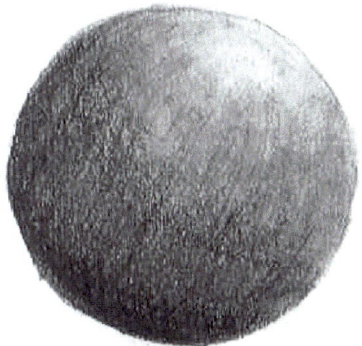

O Up to this point, you have learned how to create shadows in black and white with pencil. Creating shadow with color can be done similarly, by applying different pressure amounts or using different shades of the same color. However, as strange as this may sound, the most effective way to create dramatic shadows with color is to use the color opposite your main color on the color wheel as your shadow tone. That is, if you are coloring with red, green would be your shadow tone. Blending this shadow color up throughout the object, similar to what you do when creating shadows in black and white, will help create dimension and intermediate tones. The color wheel is as follows:

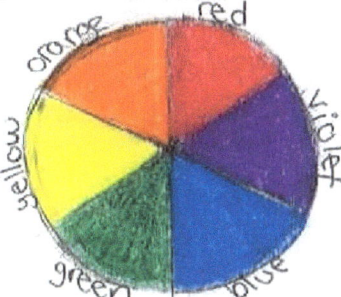

Here is an example of the same ball in the first example, but done in color using this technique:

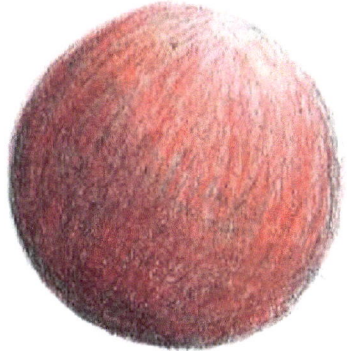

5. The Perception of the Whole or Gestalt
 - Sometimes, we can get caught up in making sure an individual section of an object looks good in our picture before moving on to the next section. This, however, can result in the drawing looking off as a whole, even if each section looks good individually. To prevent this, I would recommend taking a step back from your drawing periodically so that you can see the entire picture. This will ensure that the individual sections of your picture are coherent and harmonious together. The perception of the whole skill is pretty much just learning to use the previous four skills effectively while also accounting for how the whole image works together. An easy way to ensure that your drawing looks good as a whole is to follow these steps: first, create the main outline of the whole drawing. Then, refine these shapes around the whole drawing until you are content with how they look. Finally, add shadows and finishing details. Following these steps will ensure that all of the different sections in your drawing progress at the same rate so that they work well together throughout the entire picture.

*Remember to use these tips, exercises, and skills when drawing in the following section!

Part Three: Tutorials

The following section contains some step-by-step drawing tutorials. Each step includes a detailed description of how I drew that step, and it also includes a picture showing the step completed by hand with pencil. When drawing in this section, make sure to take into consideration everything you have learned about how to expand your artistic skill in the past two sections. Also, to adapt my tutorials to a wider variety of experience within my readers, many of the tutorials' final step is kind of like a bonus step because it brings in textures and shading for those of you who choose to make your picture more realistic. Good luck and have fun drawing!

People

Eye

1) To start, draw a subtle curve. Make sure this curve isn't too straight or too deep! This will form the upper lash line of the eye.

2) Next, connect the two bottom ends of the upper lid with another gentle curve. You have now formed the upper and lower lash lines.

3) To begin creating the iris and pupil, draw a large circle in the center of the eye that touches both the upper and lower lash lines. Then, draw a smaller circle within the larger one to form the pupil. To get your circles round and centered, you can trace around where you think the circle should be a couple of times before you actually draw it in.

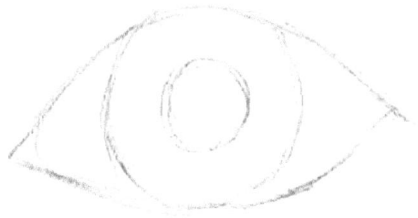

4) Now we will start adding detail to the iris and pupil. Start by shading the pupil in dark, since it is the darkest part of the eye. Also, draw a few small circles or boxes in the iris. These will later serve as light reflections on the eye, once we have shaded in the iris.

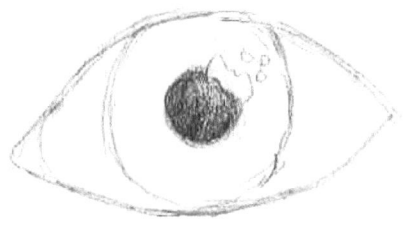

5) To give the iris detail and dimension, start in the center around the pupil and draw thin lines outward into the iris. Try to get lighter as you work outward to create light contrast. Gently blend these lines out if needed. Keep building up this pattern until you are satisfied. Remember not to color in the light reflecting areas that you made in the previous step.

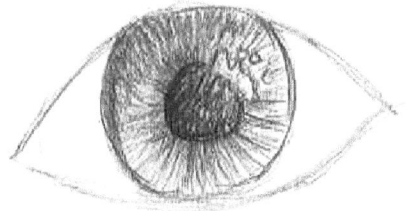

6) To finish the eye, trace over the upper lash line and extend upward in curved motions to create eye lashes. Do the same for the lower lash line, but make these lashes a little lighter.

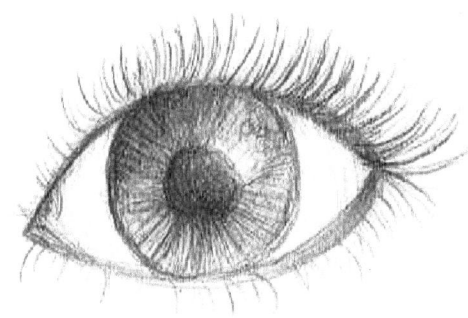

Face

1) To begin drawing the face, draw a U-shaped curve and connect it at the top to form the outline of the face. You can lightly divide the face into quadrants to more easily find the center when drawing.

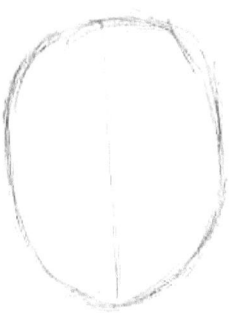

2) Next, draw the eyes. Due to your hairline, your eyes appear a lot higher on your face than they really are. They should really be located along the midline of your face. Eyes bring attention to the face, but they can be tricky, so for more detailed steps on how to draw eyes, visit the previous tutorial. Add eyebrows by creating a curves from the center of the face above the eyes.

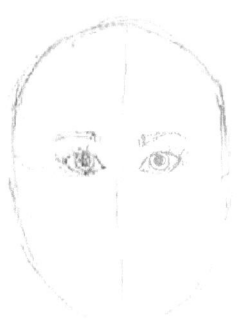

3) Next, add the nose, mouth, and ears. Start drawing the bridge of the nose from between the eyes. To form the bottom of the nose, draw one big curve with two smaller curves on either end of it. Draw the lips underneath the nose by extending a little bit from the center of the nose to form the cupids bow of the lip, and then extend these lines to create the upper lip. Connect each end of the upper lip with another curved line forming the lower lip. Draw two semi-circles from the middle of the face on each side to create the ears. Add a couple of curves and bends within the ear to create the inner-ear. The ears should line up about with the eyes.

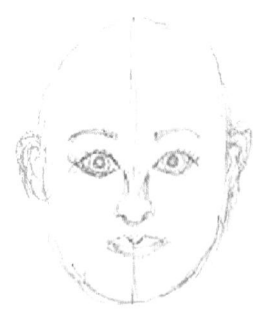

4) To add hair, create a part-line within the upper section of the face and draw two lines over the forehead that extend to the ears. Then, extend the top of the hair down along the sides of the face. You can make the hair whatever texture you choose by adding pencil marks in to create waves, curls, or straight lines. This tutorial shows long hair, but you can also draw short hair. Also, add a neck and shoulders by extending two lines that curve outward from the bottom of the face.

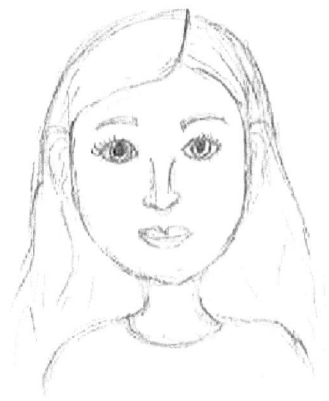

5) You're almost done! If you choose, add some final touches by creating shadow and dimension within the face. Ideal areas for this are under the chin, under the nose, on the sides of the nose, by the hair on the forehead, on the hair behind the face, inside the ears, and along the cheekbones. To learn shading, refer to the shading exercise in Part Two of this book.

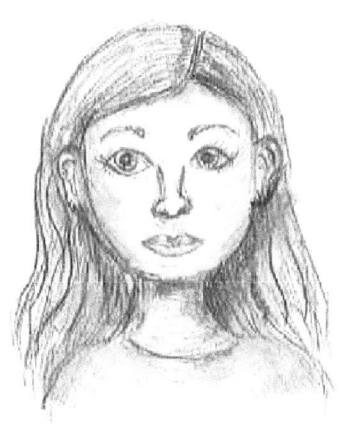

Figure

1) First, draw the face, neck, and shoulders. See the previous tutorial for how to do this.

2) Next, extend the shoulder line downward to create two arms. Make sure that your arms have a slight bend at the elbows. At the bottom of the wrist, create hands by drawing a circle for the top or palm of the hand and drawing five fingers off of it. Then, erase the circle and touch up the edges until you are satisfied. From the final finger, draw the other side of the arm by following the shape of the original side.

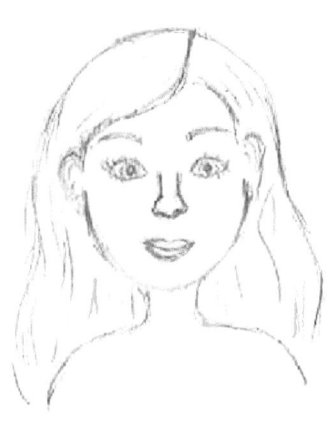

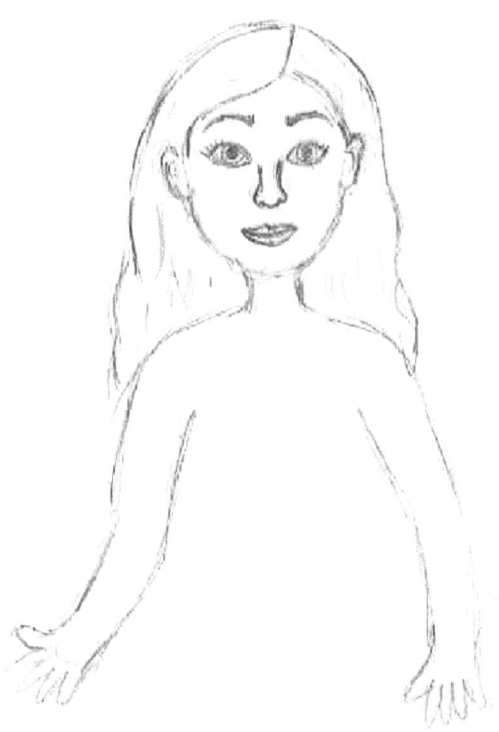

3) From the top of the inside of the arm, draw two lines down to create the sides of the stomach, and extend the lines all the way down to the bottom of the legs. To create the inside of the legs, use the same strategy as you did with the arms, making sure to follow any bends and curves in the original line. Feet are a little easier than hands since, if you draw the person with shoes on, you don't need to draw any toes.

4) To finish, draw the collar line, the bottom of the shirt on the arms and waist, and any details you wish to put in the clothes. Like the previous face tutorial, you can add realistic qualities to your person by adding shadow. This time, you decide where it is best to create this shadow/light contrast. Visit the shading tutorial and the face tutorial for some guidance.

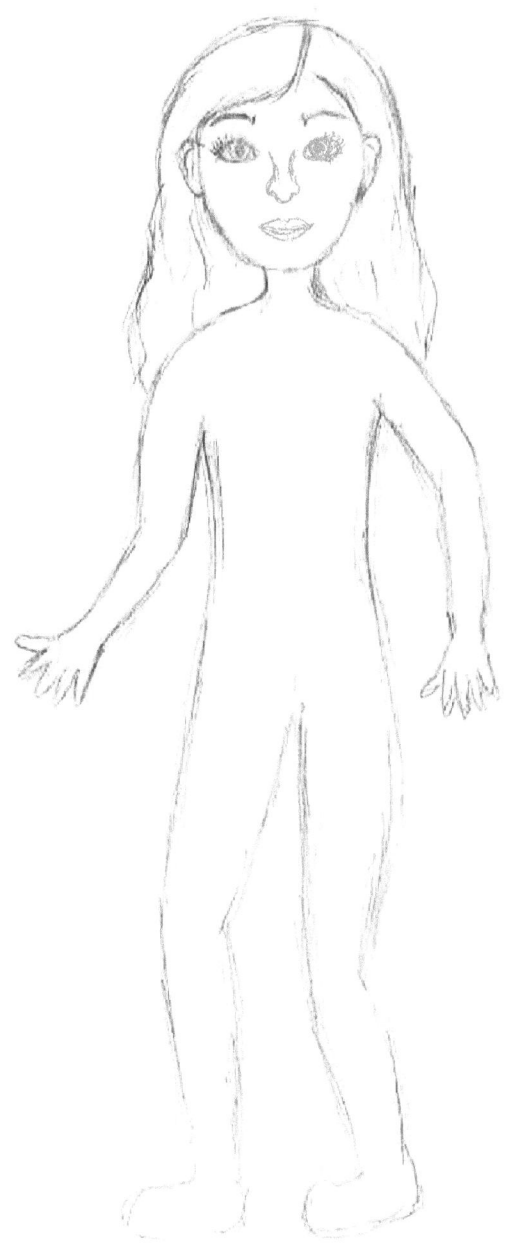
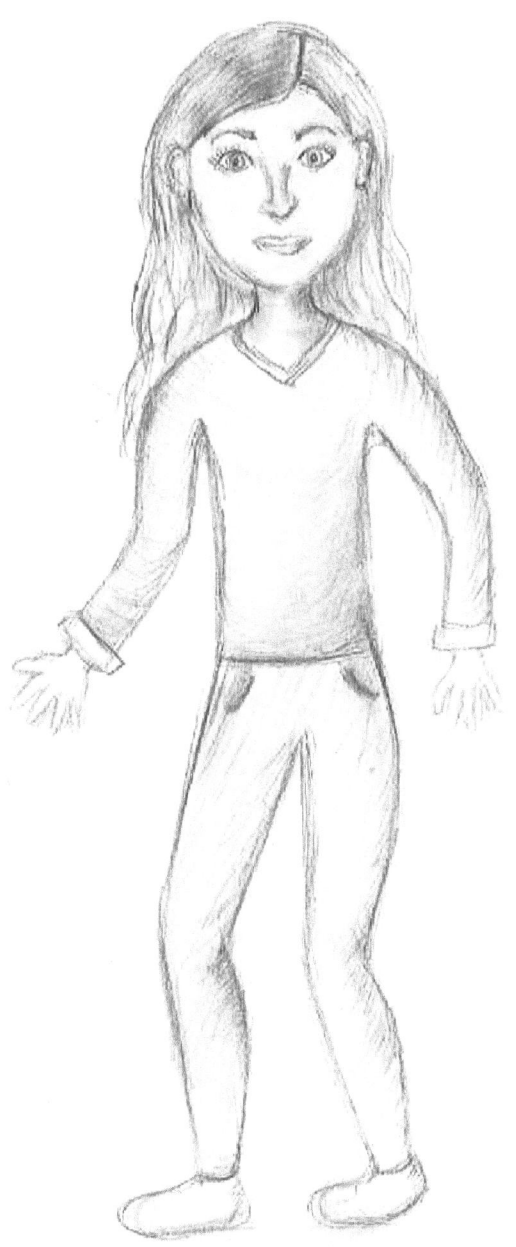

Animals

Bird

1) Begin by making two curves that curve outward in opposite directions and meet at a point to create the wing. Extend the upper section of the wing up in a semi-circle to form the back part of the neck and the head of the bird.

2) Continue the circular curve under the head to create the throat. From the end of the throat, draw another subtle curved line to form the bird's stomach.

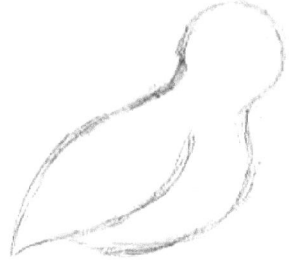

3) To draw the feet, start off by drawing two little triangles. At the tip of each of these triangles, create two stick-like legs with a bend in them. At the bottom of each leg, make four more stick-like lines in a curved form for the toes. Three of these will be in the front of the foot and one will be in the back.

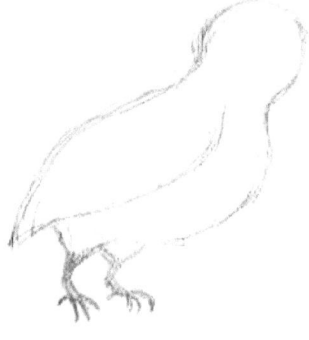

4) For the beak, draw another slim triangle off of the front of the bird's face. Also, add an eye to the bird's face.

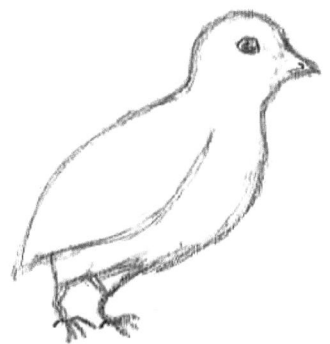

5) Add the feathery tail by drawing lines in a swooping motion from behind the wing.

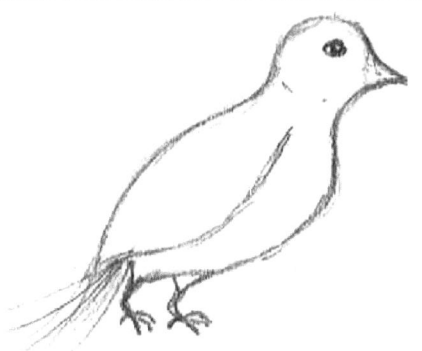

6) If you want your bird to have a more realistic texture, you can add patterns that form feathers. In the example shown, I added small, triangular-shaped feathers on the wings. Notice how these get longer as I go down toward the tip of the wing. I also added some texture to the stomach with little dots, and I shaded the area around the head and neck to add some dimension and contrast.

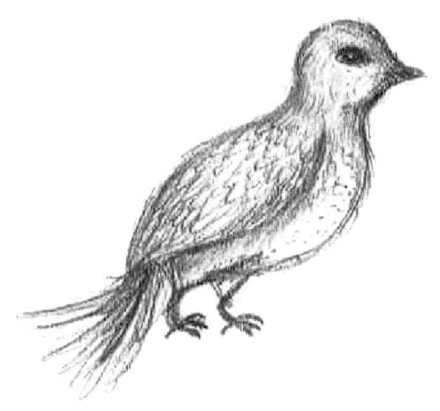

Dog

1) Begin by drawing a relatively straight line with a half-U-shaped curve under it. This forms the snout. After doing this, you can round off the tip of the snout. Then, from the end of the line on top of the curve, draw a circle to form the head.

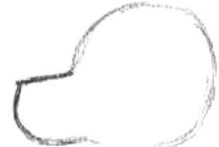

2) From the bottom side of the circle, extend an inward curve to draw the back of the neck. From the end of this curve, draw a straight line for the back. At the end of this line, curve it under the figure to form the back of the hind leg. Repeat this same step on the front for the neck and chest.

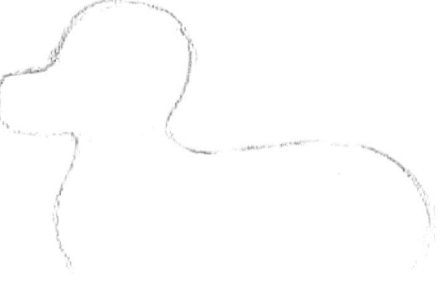

3) Now we will create the front and hind legs. Do this by forming semi-circular curves in the opposite direction of the curves you made in the previous step. This will form the other side of each leg. As you extend these lines downward to create each leg, make sure to have a slight bend in the leg where the joint would be. Finish each leg off with an oval-ish shaped foot. You can also add individual toes to the paws. To finish this step, draw a line in-between the top of the legs for the belly.

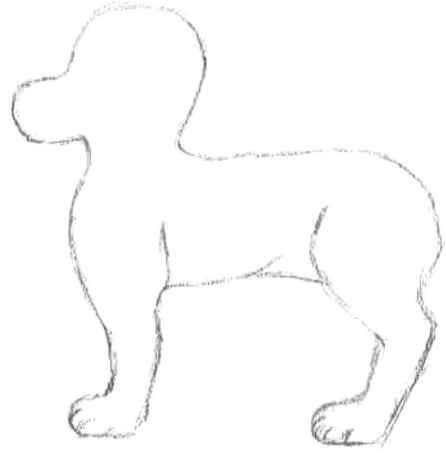

4) Now add the tail by continuing a swooping curve off of the dog's back. Also, add an ear to the head by drawing a U-shaped curve off of the top of the head. Add facial features by creating a triangle-shaped nose on the tip of the snout and a line for the mouth under the nose. Draw an eye next to the ear.

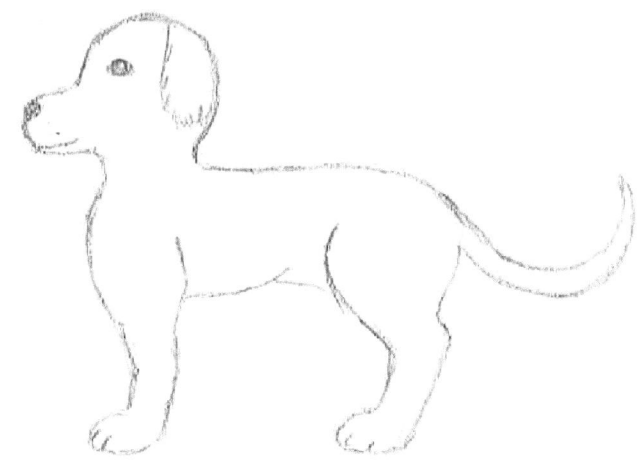

5) If you want to, you can finish your dog with some shading and fur textures on the face and body, just like you may have done with the previous tutorials. As a reminder, be sure to read the section on shading in Part Two of this book if you want a way to enhance your shading skills.

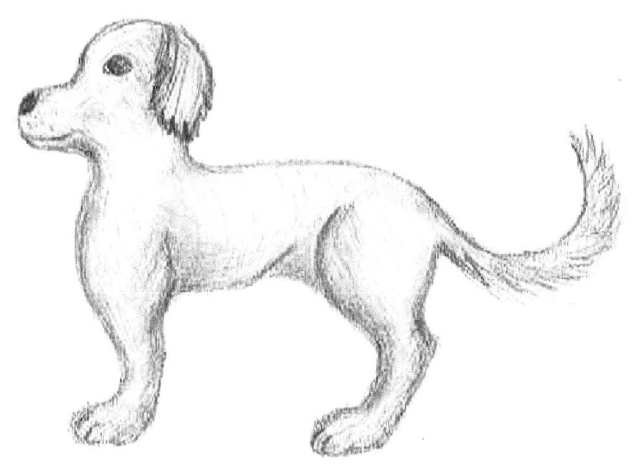

Bunny

1) Start by drawing a side-ways oval for the head. From this oval, draw a curve to form the back of the bunny and another smaller curve in the front for the neck and chest.

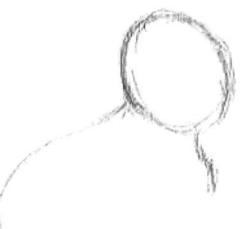

2) Form the inside of the hind leg by creating a semi-circle in the opposite direction of the back of the hind leg. From the bottom of the leg, draw a long hind foot.

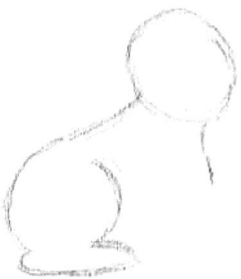

3) Repeat the previous step for the front leg(s). In this picture, I chose to arrange my front paws with one of them bent upward and the other one behind it, but you can arrange your bunny's feet however you like! Connect the front and back legs with a line for the belly.

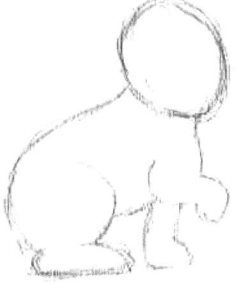

4) Now draw two carrot-shaped ears from the top of the head. You can create the inside of an ear by drawing a similar shape inside of the ears you already drew.

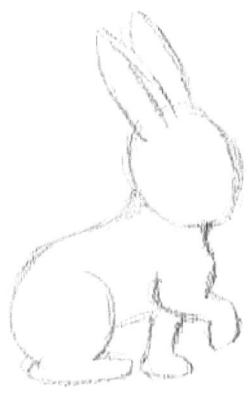

5) Add a large, round, and fluffy tail to the back of the bunny. Add texture to the tail if you choose by creating little dots and short, curved lines.

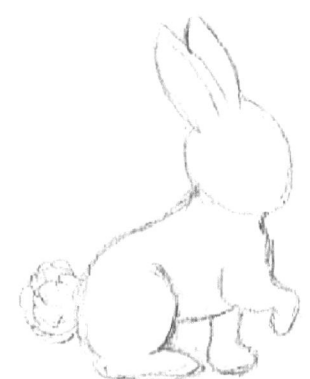

6) Now add the facial features. Draw a triangular nose toward the bottom of the face with two curves extending out from the nose in opposite directions for the mouth. You can create a faint line extending upward from the edges of the nose as a guide for the eyes.

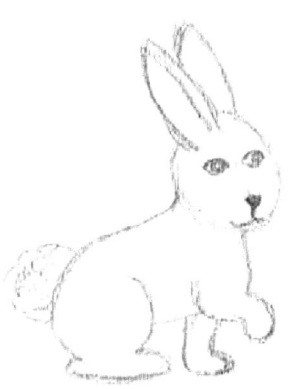

7) As always, you may add fur textures and shading to the rabbit. I did this within the ears, on the tail, around the face and nose, and on the body around the legs.

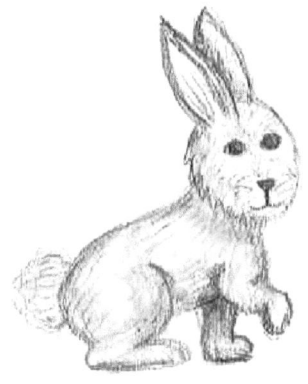

Objects in nature

Rose

1) To draw a simple rose, start by drawing a swirling oval that forms the center.

2) Now, start adding small and tightly-woven petals around this center. The farther away you go from the center, the larger and looser the petals will be drawn.

3) Continue adding petals... Remember, to achieve the most realistic look, each layer of petals should overlap the layer before it. Also, keep in mind that petals look more realistic if they are slightly curled at the ends and not perfectly shaped!

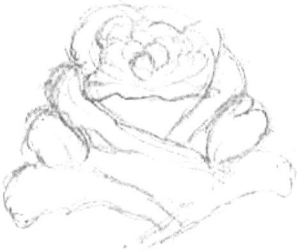

4) After you have built up the amount of petals in your rose that you desire, curve off the bottom with two petals, one on each side of the center.

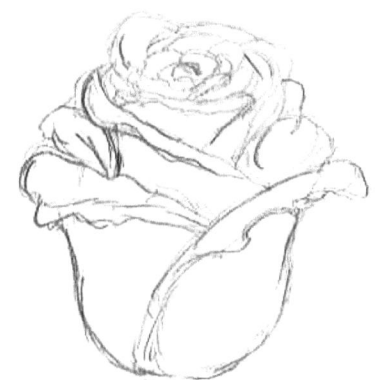

5) To create the bottom of the rose where it attaches to the stem, draw skinny, spiky leaves off of the base. From the center of these leaves, you can draw a slightly bent, narrow stem. In this picture, I did not extend the stem all the way down to its tip, but you may draw the whole stem if you want to. I chose to do it this way because I wanted the focus of my picture to be on the actual rose bud, but you may lay out your picture however you like!

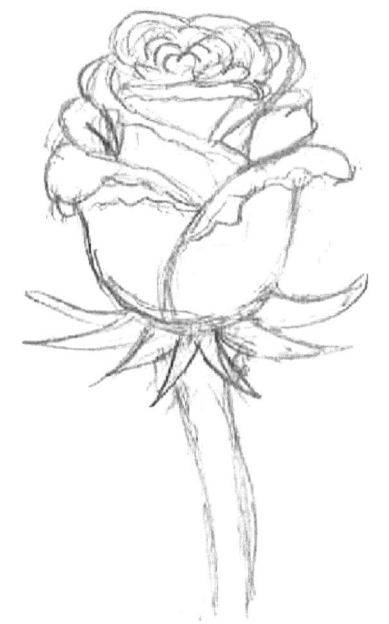

6) Adding shadow and dimension to a rose is a great way to make the petals stand out. In the example shown, I shaded in-between the petals to make them pop out from the petals that they overlap. I also shaded the areas under the curled tip of each petal to make this curl in the petal seem more life-like and dimensional.

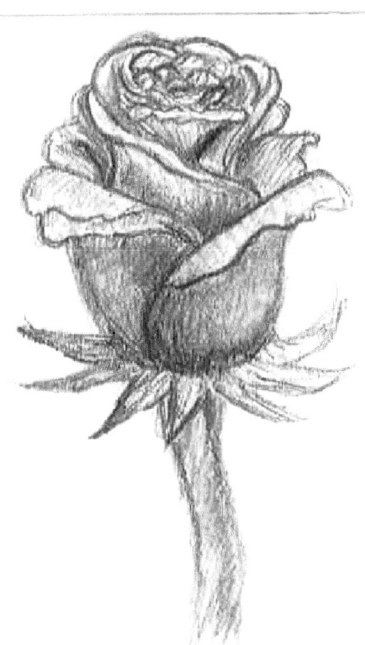

Leaf

1) First, draw a small stem. From one end of this stem, create the five main veins of the leaf. These help section off the leaf.

2) Next, create a rough outline of the leaf. Use the five veins as a guide for where to position the tip of each section. Make sure this outline is drawn lightly because we are going to be going over it with more detail.

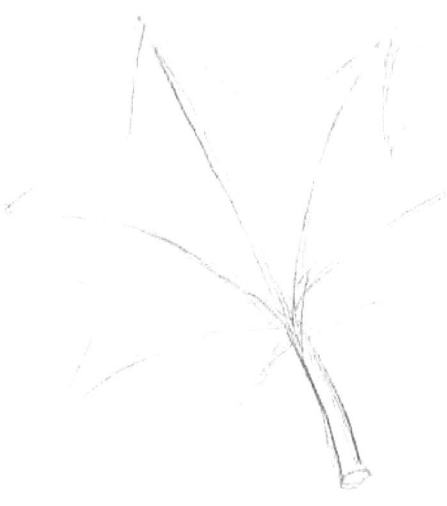

3) Now, go around the rough outline with little curved triangles. Each one of these should work up to the tip of the vein in its section.

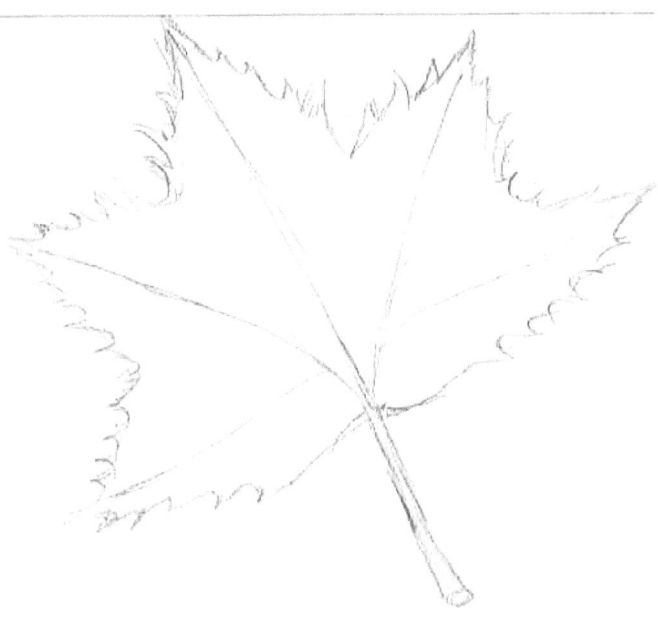

4) Add detail by adding lighter veins within the leaf by branching off of each of the five larger veins towards its tip. You can also add some shadow to different areas on the leaf for some light contrast.

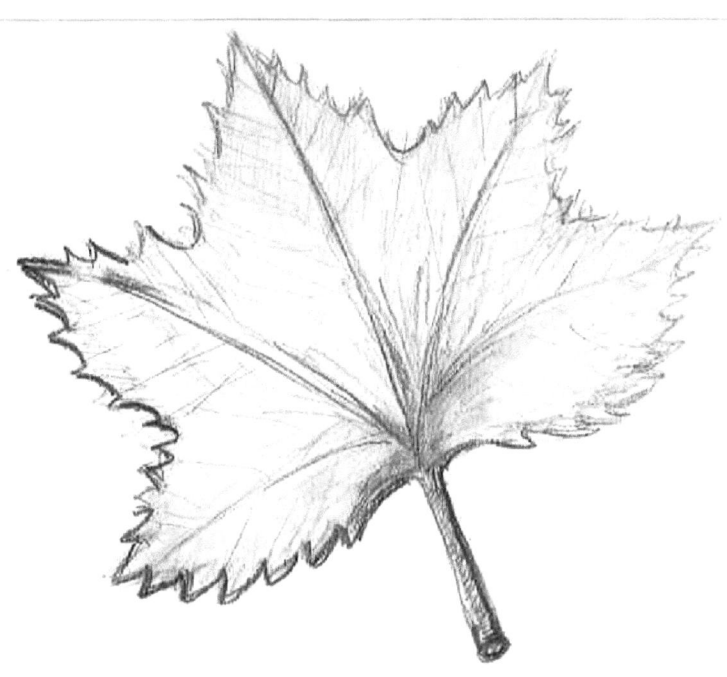

Tree

1) To begin, draw the trunk of the tree with roots splaying out from its bottom. Extend this line up to form the body of the tree. Most trees in nature are not perfectly straight, so add a little curved structure.

2) Next, start adding the main branches from the top of the tree's body. Make sure that all of these branches actually connect to the body so that they aren't coming out of nowhere!

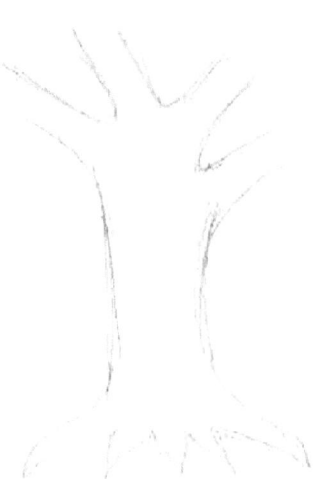

3) Now start adding smaller branches coming off of these main branches. Then, add even smaller ones branching off of the branches you just created until you are satisfied. Sketch a bushy outline around all of the branches to start the outline of the leaves.

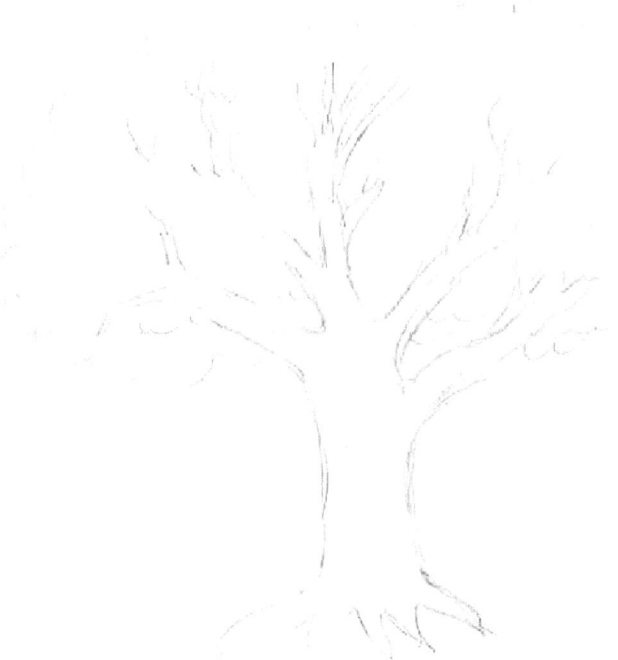

4) Begin to add some texture to the leaves around the branches. Do this by adding small fluffs of leaves within your outline and by enhancing your outline with more detail. You can make your leaves more realistic and detailed by adding some light contrast around the branches. Doing this will also help build up the texture of the leaves.

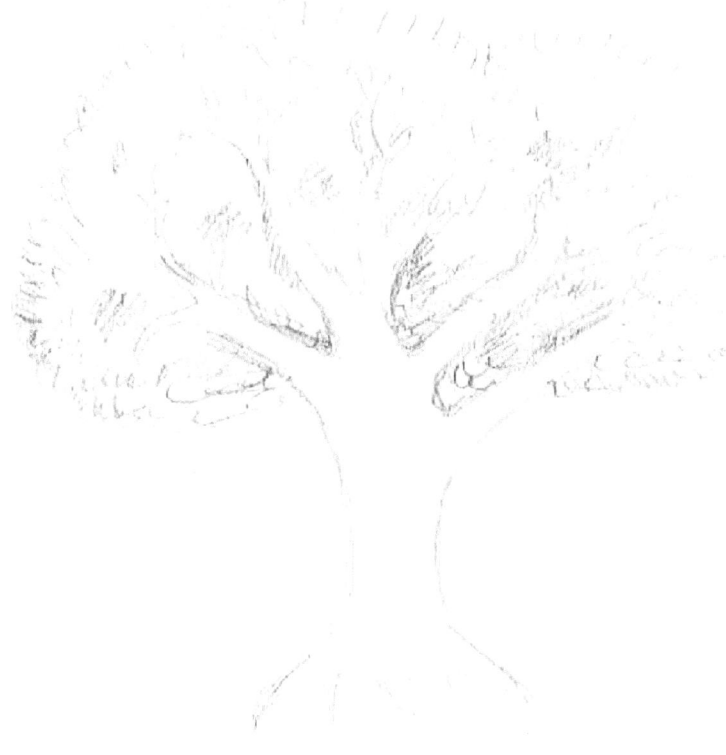

5) To finish the tree, add shading to the trunk and branches. I used a shading method called **cross hatching**, where you cross small lines over each other in opposite directions, to create shadow tones. Adding lines of shadow to your tree will also help give texture to the trunk.

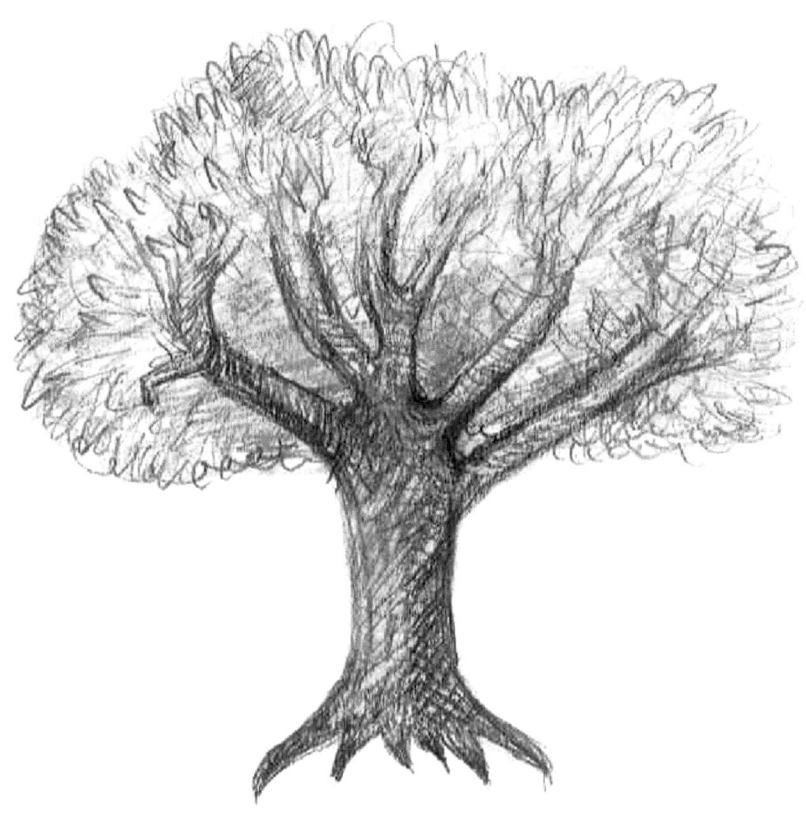

Conclusion

Congratulations! You have finished learning how to draw with my method in this book. I hope that you were able to gain confidence in your artistic skill and maybe even find a new interest in art. Whether you have always considered yourself an artist, or you potentially just found a new skill, remember to continue expanding your artistic interest by drawing more of whatever you are interested in using some of your newfound artistic skills. Thank you for using my book. Happy drawing!

Resources

Balsley, Jessica. "5 Reasons to Love and Hate How-to-Draw Books." *The Art of Ed RSS*. N.p., 21 June 2012. Web. 2 Jan. 2016.

Bartel, Marvin. "How to Teach Drawing to Children." *Goshen*. N.p., 2002. Web. 2 Jan. 2016.

Black, Anna. "Drawing Books." *Learn-to-Draw-Right*. N.p., 2007. Web. 10 Jan. 2016.

Edwards, Betty. Drawing on the Right Side of the Brain: A Course in Enhancing Creativity and Artistic Confidence. Los Angeles: J.P. Tarcher, 1989. Print.

Johnson, Dan. "The Five Basic Skills of Drawing. " *Right Brain Rockstar*. N.p., 2012. Web. 10 Jan. 2016.